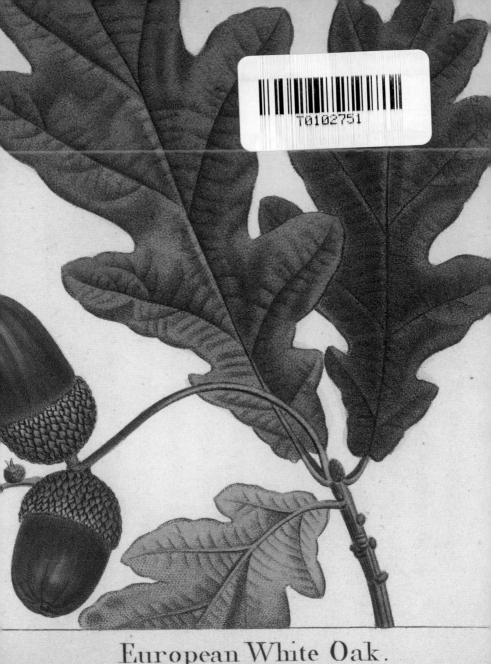

European White Oak.
Quercus pedunculata.

KEW POCKETBOOKS

TREES

Introduction by Kevin Martin
Curated by Lydia White

Kew Publishing
Royal Botanic Gardens, Kew

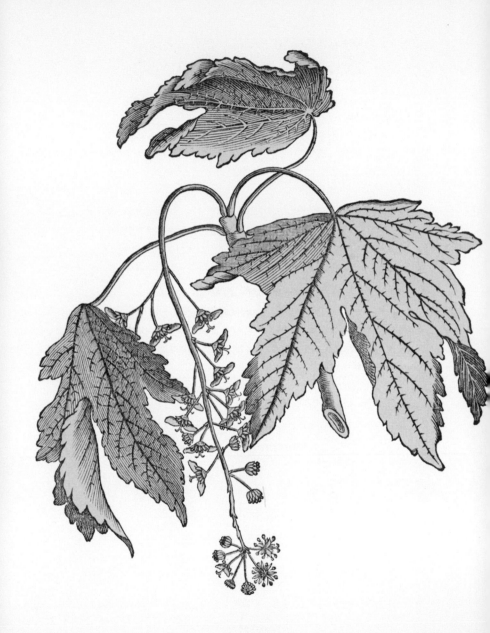

KEW HOLDS ONE OF THE LARGEST COLLECTIONS of botanical literature, art and archive material in the world. The library comprises 185,000 monographs and rare books, around 150,000 pamphlets, 5,000 serial titles and 25,000 maps. The Archives contain vast collections relating to Kew's long history as a global centre of plant information and a nationally important botanic garden including 7 million letters, lists, field notebooks, diaries and manuscript pages.

The Illustrations Collection comprises 200,000 watercolours, oils, prints and drawings, assembled over the last 200 years, forming an exceptional visual record of plants and fungi. Works include those of the great masters of botanical illustration such as Ehret, Redouté, the Bauer brothers, Thomas Duncanson, George Bond and Walter Hood Fitch. Our special collections include historic and contemporary originals prepared for *Curtis's Botanical Magazine*, the work of Margaret Meen, Thomas Baines, Margaret Mee, Joseph Hooker's Indian sketches, Edouard Morren's bromeliad paintings, 'Company School' works commissioned from Indian artists by Roxburgh, Wallich, Royle and others, and the Marianne North Collection, housed in the gallery named after her in Kew Gardens.

INTRODUCTION

SINCE MY WORK BEGAN AT THE ROYAL BOTANIC
Gardens, Kew over a decade ago, I have had the privilege
of caring for and managing over 12,000 very special
trees. During this time, I have learned so much from
them, as trees indeed have much to teach us. Now, as
Head of Tree Collections, I look towards the future.

The past these trees have lived through is no longer their
future and we must work with them and their unique
abilities to cope with what is to come.

The living collection at Kew is a hugely important
resource. If not only for the heritage and conservation,
but for science and to the history of Kew. However, there
is now a new importance to understand the changing
world around us. With trees collected and represented
throughout the Arboretum from all over the temperate
world, they will now become the most valuable
resource as we try to understand the consequences of
the changing climate to our natural world. With such
a diverse collection of trees in one place, which all
started with Queen Caroline's passion for gardening
in the 1700s, and then with William Hooker's passion

for a national arboretum here at Kew, there have been legacies left from which we all benefit today.

With first introductions of many species, we can observe how trees have adapted to changing climates. What we can observe is not only which tree species are best suited to particular growing environments, but also the provenance of species. We only have to stand and admire the *Zelkova carpinifolia* at Kew's Brentford Gate. This magnificent tree is native to the Transcaucasian forests from Russia to Iran. As we use advances in climate modelling and species occurrence data, we can now match suitable climates globally to Kew. With these new advances, it allows us to understand the importance of environmental matching for tree selection. *Zelkova carpinifolia* is one of the most suitable tree species for Kew's growing environment and this is evident in the collection today. With the first introduction of the species in the Arboretum believed to have been planted in the mid-1700s, it has never missed a beat and is still growing magnificently today.

With the climate changing before our eyes, as custodians we must take the responsibility to plan ahead, but act now, at a time when we are fortunate to have the choice in what species we plant and where.

I have observed how the drought and heat has affected some of our tree species in the collections and how the different trees have coped, or not. It is a startling insight

into what is ahead. With climate change impacting us all, we must now understand the importance of trees in our urban habitat. We must remember the endless work trees do for us all.

With evidence the UK's climate is continuing to change, recent decades have been warmer, wetter, and sunnier than the 20th century. Mature tree canopy cover disrupts the local effects of urban heat islands whilst providing important ecosystem services. For example, energy saving through the cooling effects of trees by providing temperature decrease via evapotranspiration, shading of impervious surfaces, the removal of pollution and assisting with storm water runoff and carbon sequestration.

With more than 50% of the world's population now living in urban areas, green infrastructure including parks, forests, street trees, gardens, cemeteries and green roofs will all play a vital role in being the main carrier for ecosystem services. This will become ever increasingly important to improve and maintain a quality of life for urban dwellers, with economic and social benefits, as well as for our health and well-being, providing abiotic, biotic, and cultural functions to advance and contribute to urban sustainability.

With trees providing us all with these important benefits we must now do our very best to understand what is required for trees to establish in the most hostile

environments. The urban environment is a far cry from the natural environment which trees inhabit.

With this at the forefront of our minds, this book will take you through a journey of some of the more unusual trees, which in time, may become part of the environment around us as we learn to adapt to the new normal.

I have taken the time to curate a list of 40 tree species in this book, that I hope you will find fascinating and inspiring for future tree planting. Some of you will be familiar with some that are in cultivation already, but I hope you will find interesting those trees which are not currently seen in our gardens today but have the potential to become more commonplace in the future. I have enjoyed exploring what makes these trees unique and how they herald the future of the treescape in our parks, gardens and more importantly, our streets as urban canopy cover.

Along with beautiful botanical illustrations, you can find a short summary about each species. Where is it from? Why does it thrive so well in its native country? And how can we utilise its natural traits to deal with the urban environment?

We are encouraged to plant more trees, now more than ever, as one of the ways to try and stop global temperatures from rising. What we really must understand is what is required for trees to establish,

survive, and thrive. Otherwise planting them will never leave the legacy we take for granted in the landscape and which we all get to enjoy in our day to day lives.

I hope that this collection can demonstrate to you, the reader, that there are interesting varieties out there that can be utilised in everyday planting, and by planting trees we can all do our bit for future generations, and in time with advances in tree selection methods, we stand a better chance of trees establishing in the toughest of environments.

After all, the best time to plant a tree is yesterday, but the next best time is now!

Kevin Martin
Head of Tree Collections
Royal Botanic Gardens, Kew

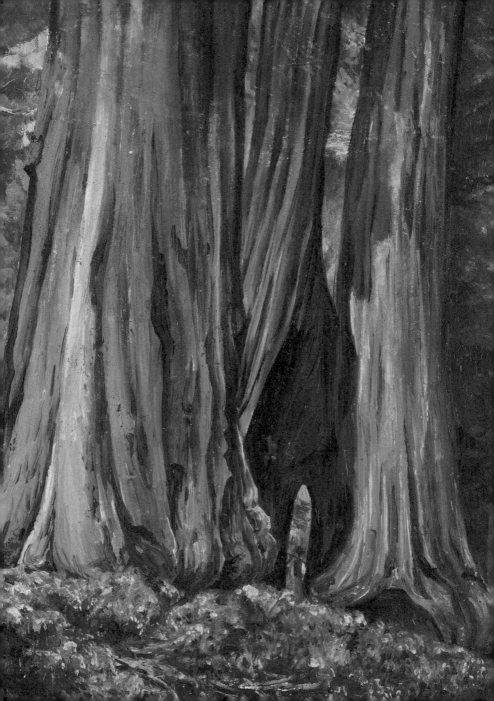

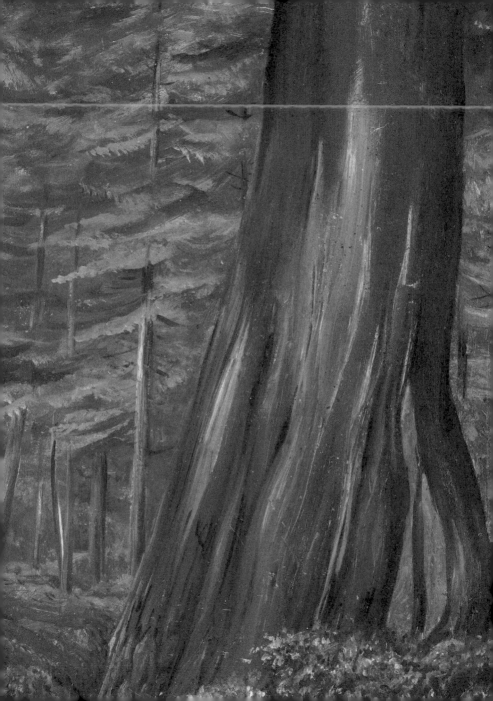

Carpinus orientalis

Oriental hornbeam
from Pierre Mouillefert
Traité des Arbres et Arbrissaux, 1892-8

Often overlooked, this is not a showy tree, but looks aren't everything. Its natural distribution range is that of dry and rocky slopes at low elevation in South-East Europe to the Black Sea and the Caucasus region. This is the most drought-tolerant hornbeam, which allows its foliage to be an important food source for livestock fodder in times of drought summers when grasslands are completely perished.

Acer monspessulanum

Montpellier maple
from Johan Carl Krauss *Afbeeldingen
der Fraaiste, Meest Uitheemsche
Boomen en Heesters*, 1802

A fantastic small tree, with small and
uniform three-lobed leaves. Its bark turns
from pale brown to grey and fissures with
age. Native to the Mediterranean region,
this is certainly a tree for the future and
could easily become one of the popular trees
planted out in our landscapes.

Pinus sylvestris

Scots pine
from John Stephenson
Medical Botany, 1835

This tree has a large distribution range from Scotland through Scandinavia and the Baltic region to the Russian Far East. With its north-south range from beyond the Arctic Circle to the borders of the steppe, the Scots pine holds high economic value with the timber having multiple uses. Well suited to poor soils and warmer, drier climates makes the species ideal as a production tree.

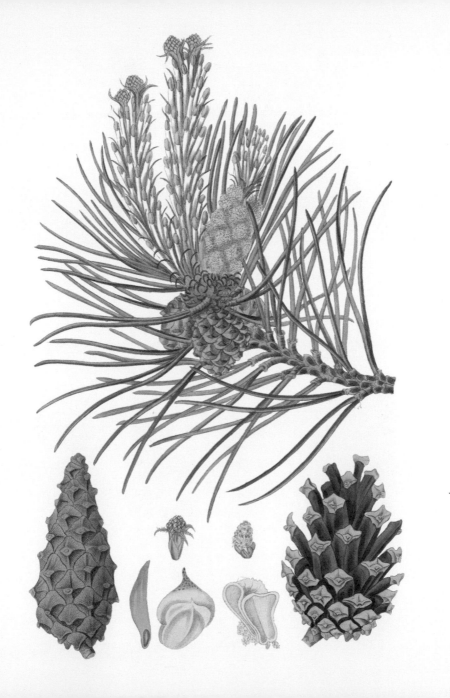

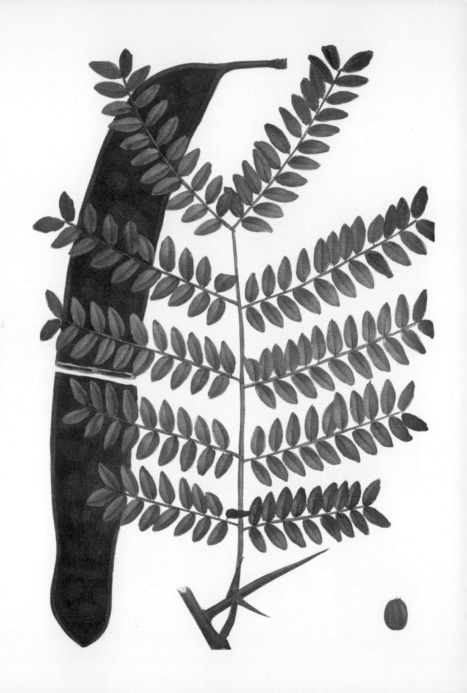

Gleditsia triacanthos

honey locust
by Pancrace Bessa
from Francois Andre Michaux
The North American Sylva, 1819

––––––––––

An underrated species, this tree has fern-like
foliage and eye-catching autumn colour of
striking bright yellow. Its common name
is the honey locust, although the species is
not related to the production of honey. It
is in fact referring to the sweet taste of the
legume pulp, traditionally used for food and
medicine by Native Americans, and it can
also be used to make tea.

Arbutus unedo

strawberry tree
from Henri Louis Duhamel du Monceau
Traité des Arbres et Arbustes, 1800-19

This species' common name comes from the
bright yellow and red fruits which appear in
autumn. With its natural range being that of the
Mediterranean to the north coast of Africa, it
is well adapted to survive summer drought and
growing on free draining rocky soils. The fruit
is rich in therapeutic properties and is a great
source of vitamins and tannins, and is used to
make jams and jellies.

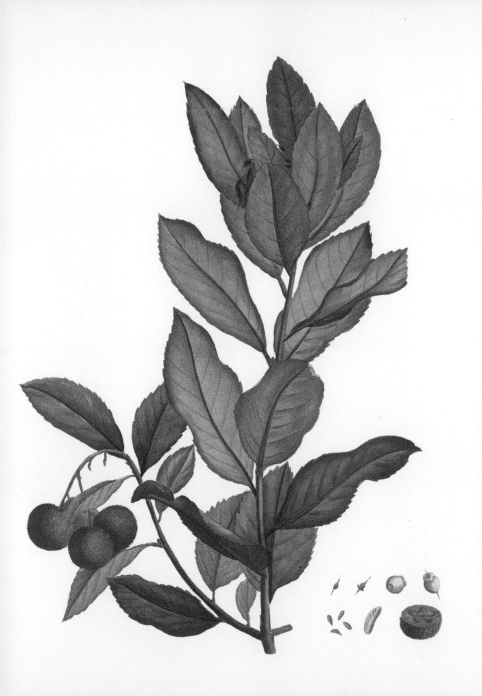

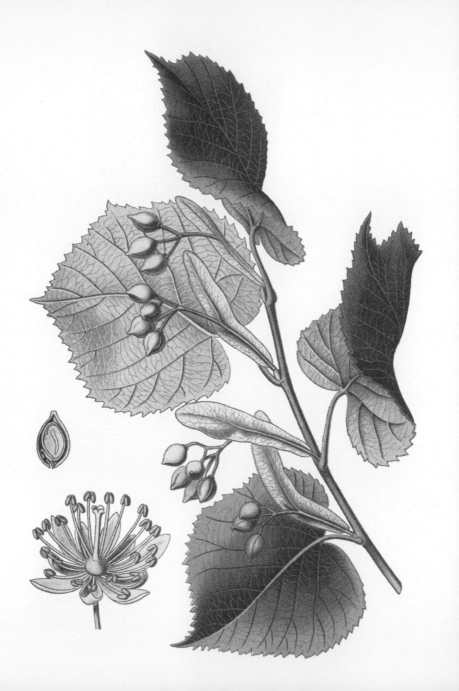

Tilia tomentosa

silver lime
from Pierre Mouillefert
Traité des Arbres et Arbrissaux, 1892-8

This elegant tree plays a very clever trick
through the summer days. As temperatures
increase along with light levels, the tree
twists its leaves to show the silvery underside,
hence its common name, the silver lime.
Commercially grown for its timber in Bulgaria
and Romania, in the British Isles it is planted
as an amenity tree with many of the large
specimens planted in and around 1800.

Pterocarya fraxinifolia

Caucasian wingnut, Caucasian walnut
by J. T. Descourtilz from Michel Étienne
Descourtilz *Flore Pittoresque et Médicale
des Antilles*, 1821-9

———————

This tree likes moist soils and is found in the
wild growing on riverbanks in the southern
Caucasus. With its showy chain-like fruits
and autumnal bright yellow leaves, it is one
of the most intriguing trees to admire in the
landscape. The species has a reputation of being
very vigorous in producing epicormic growths
so care needs to be taken with its management
and planting location.

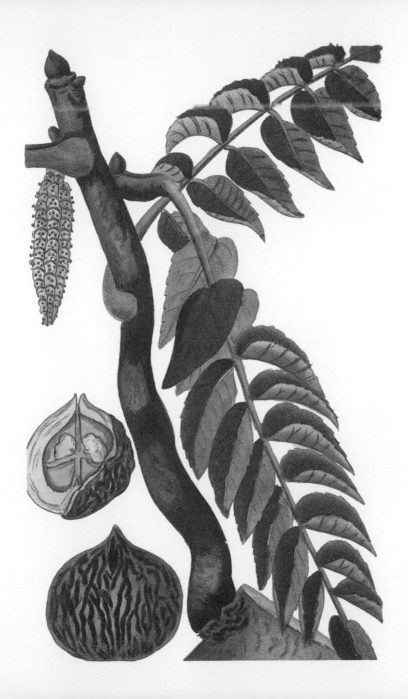

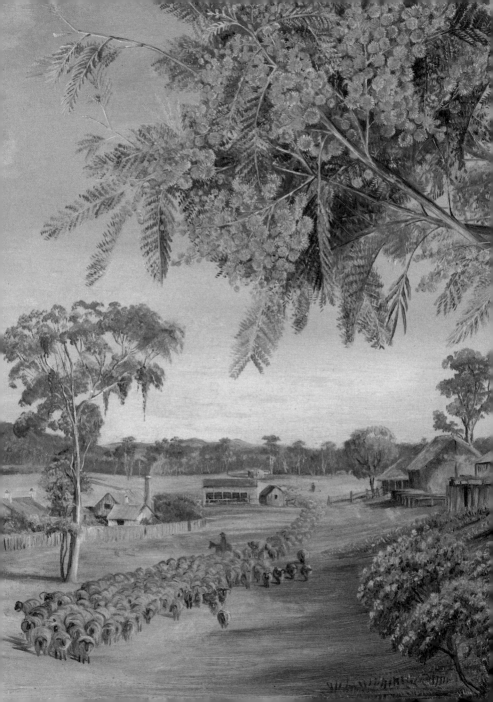

Acacia dealbata

blue wattle, silver wattle, mimosa
by Marianne North from the
Marianne North Collection, Kew, 1880

―――――――――

This fast-growing evergreen tree, native to
Australia, was first introduced into the UK in
1820 from Tasmania. Commonly called blue
wattle or mimosa, this species makes a fabulous
garden tree with silvery, feathery foliage and
clear yellow, fragrant flowers making the most
wonderful combination for any urban garden.

Aesculus indica

Indian horse chestnut
from L. Van Houtte *Flore des Serres
et des Jardins de l'Europe*, 1875

The Indian horse chestnut is an extremely
useful replacement for the common horse
chestnut. The chemical composition of the
leaves is disliked by the leaf miner (*Cameraria
ohridella*), a pest which causes the leaves of
the common horse chestnut to go brown in
late summer. Native to the northwest of the
Himalayas, the foliage of this tree is used for
cattle fodder in its native lands, and the seeds
are ground into a bitter flour called tattawakher.

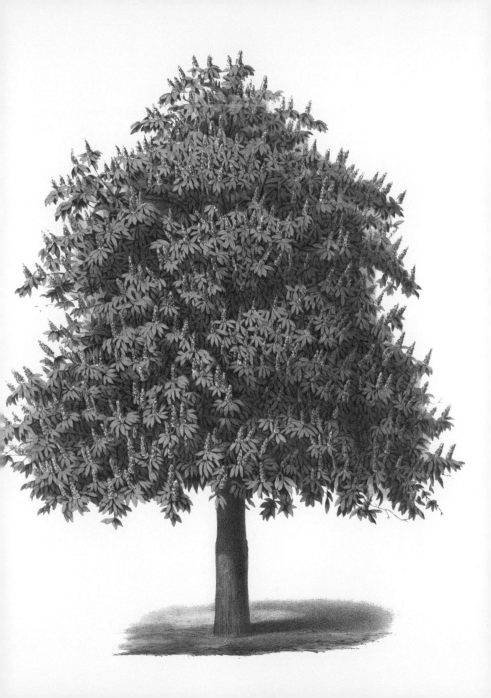

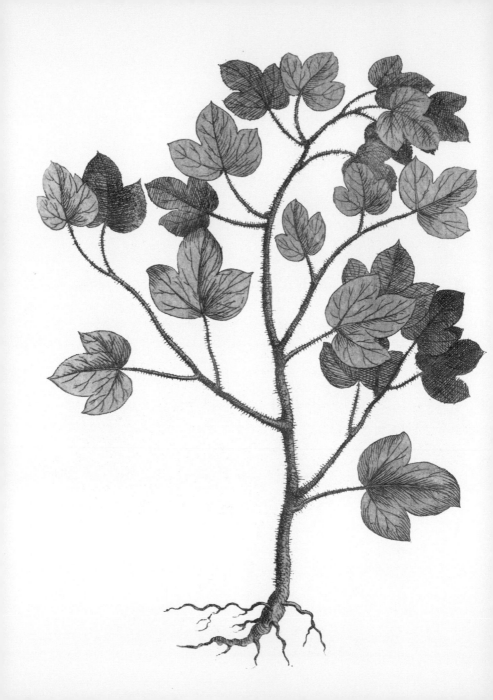

Acer sempervirens

Cretan maple
from Prosper Alpini
De Plantis Exoticis Libri Duo, 1627

This tree can be found growing in Greece
and Turkey and is a semi-evergreen shrub
or small tree. It's one of the only evergreens
in the genus, and has bright green leaves,
green-yellow flowers, and brown-red winged
fruits. This underutilised tree is ideal
for planting in small gardens with great
resilience to hot, dry summers.

Fagus grandifolia

American beech
by Pierre Joseph Redouté
from Francois Andre Michaux
The North American Sylva, 1819

———————

The American beech has its native range in
the eastern United States and the extreme
southeast of Canada. As with many of the
trees from its native range, it has an attractive
autumn foliage of bright yellow. Not commonly
found in cultivation due to the difficulties
in establishing, the American beech is
more adapted to hotter climates than its
European counterpart.

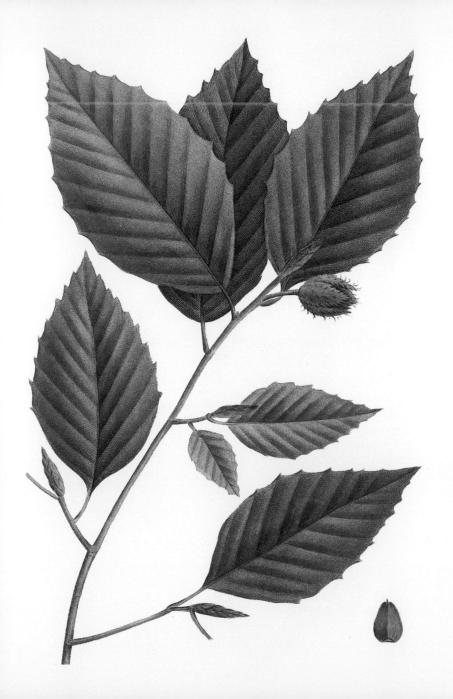

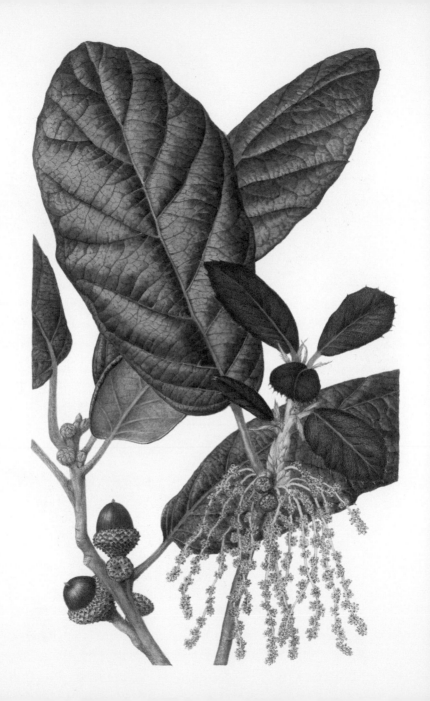

Quercus crassifolia

Mexican oak
by Christabel King from
Curtis's Botanical Magazine, 2012

This oak from central Mexico produces red
velvety new shoots, with leaves unlike any
European species of oak, with extremely
thick leathery leaves, and the underside
covered in fine hairs, giving it a very unique
appearance in a traditional landscape.
Here at Kew, we have the British and Irish
champions, planted in 1934.

Quercus ilex

big-cone pine
from Franz Antoine
Die Coniferen: nach Lambert,
Loudon und Anderen, 1840-1

This is one of the evergreen oaks from cold,
semi-arid Mediterranean climates at high
altitudes. The species was first introduced to the
UK in the 1500s and has become naturalised.
Extremely versatile, it can withstand many
different types of management including
topiary, and wind break plantings, and is often
planted in parks and gardens as a specimen tree.

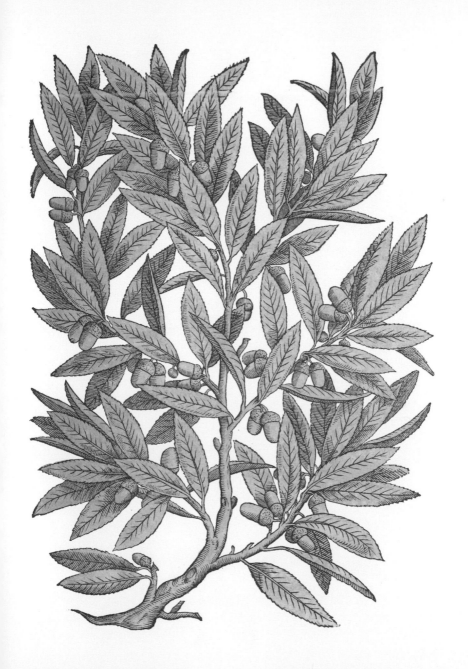

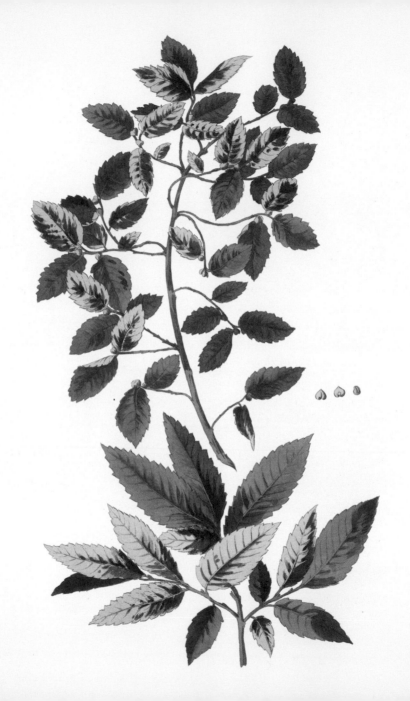

Zelkova carpinifolia

Caucasian elm
by Karl Friedrich Knappe
from Peter Simon von Pallas
Flora Rossica, 1784-8

A large, elegant and distinct tree with an upright growth habit, with cluster stems, fluting buttresses and flaking bark. This magnificent tree is native to the Transcaucasian forests of Russia to Iran. It been evaluated as Vulnerable in Georgia and Azerbaijan, due to extensive logging for its valuable timber, the dense wood being resistant to damp.

Magnolia grandiflora

magnolia, bull bay
by Georg Dionysius Ehret
from Christopher Jacob Trew
Plantae Selectae, 1750-73

This wonderful, often thought to be frost-sensitive, tree can be found growing up against many period properties. Native in the South-eastern United States, from Virginia south to central Florida, it has large glossy leaves with soft brown velvet undersides, with the most fragrant lemon-scented white flowers. Native Americans of the south-east used the bark from this tree to treat swelling, itching and sores.

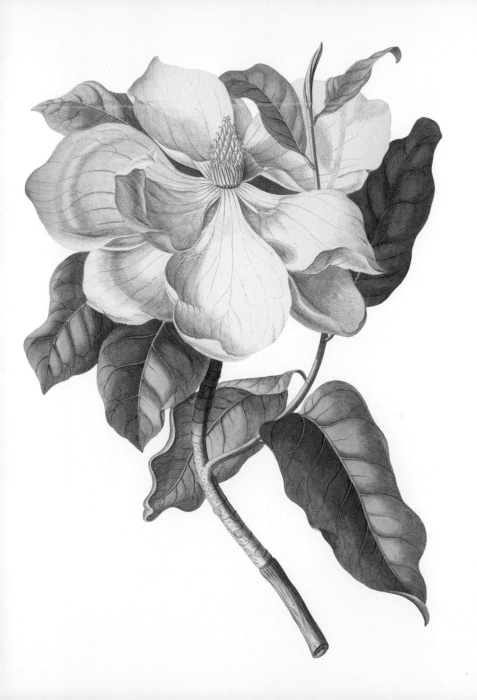

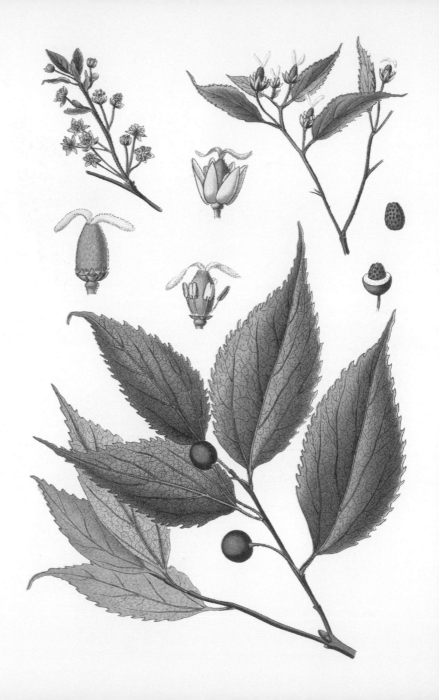

Celtis australis

**Mediterranean hackberry, European
hackberry, nettle tree, European nettle tree**
by Otto Wilhelm Thomé
from *Flora von Deutschland, Osterreich
und der Schweiz*, 1886-9

As the common names suggest, this species is
commonly found growing in southern Europe,
North Africa, and Asia Minor. In its native
habitat in the warm sunny south of Europe, it
is believed to live up to a thousand years. It is a
fantastic urban tree used throughout southern
Europe for its durability and ability to thrive in
areas subjected to reflected heat and light.

Arbutus × *andrachnoides*

hybrid strawberry tree
from Sydenham Teast Edwards
Edwards' Botanical Register, 1822

Formed in Greece, this magnificent hybrid of
Arbutus unedo and *Arbutus andrachne*, is a small
tree with high visual impact, with bright red
flaking bark, with young and vibrant green bark
beneath. The white flowers are tinged with pink
from the autumn to the spring and will bring all
year-round garden interest.

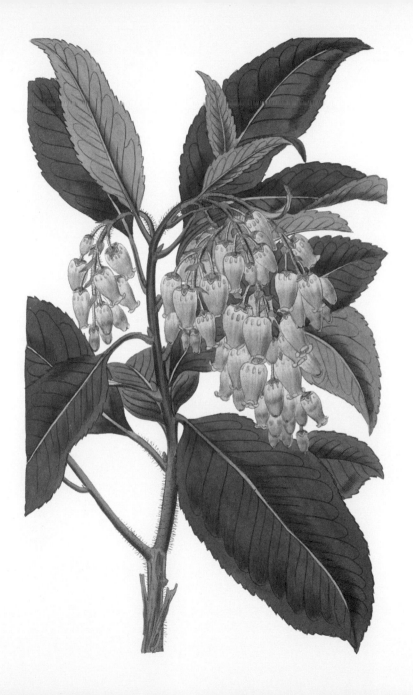

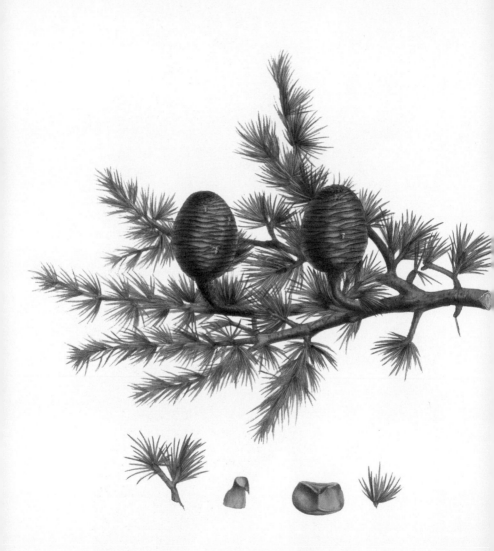

Cedrus atlantica

Atlas cedar
from Edward James Ravenscroft
The Pinetum Britannicum, 1863-84

As the common name suggests, this species is
from the Atlas mountains which run northwest
through North Africa to the Rif mountains of
Morocco. The natural distribution of this once
widespread tree decreased by 75% by the 20th
century, due to the complex issues of climate
change and new pests and diseases.

Carpinus betulus

common hornbeam, European hornbeam
from Carl Axel Magnus Lindman
Bilder ur Nordens Flora, 1922-6

Hornbeam translates into modern English as
'hard tree'. This is the most common hornbeam
in Europe and southeast England, with its
distribution spreading to western Asia and
central, eastern, and southern Europe.
It is often confused with the common beech
in the winter months, but unlike the beech,
the hornbeam can grow in seasonally
waterlogged conditions.

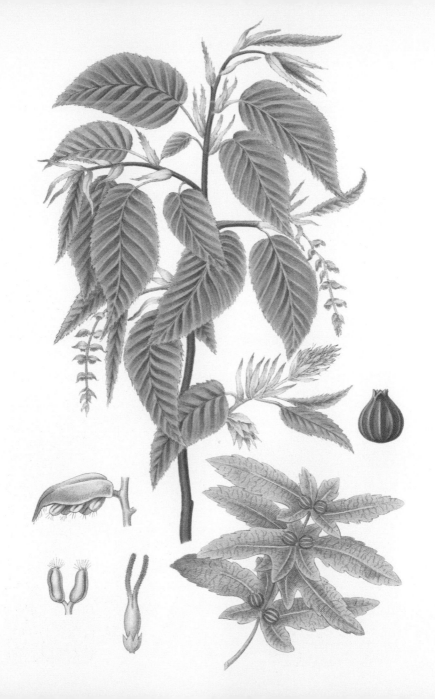

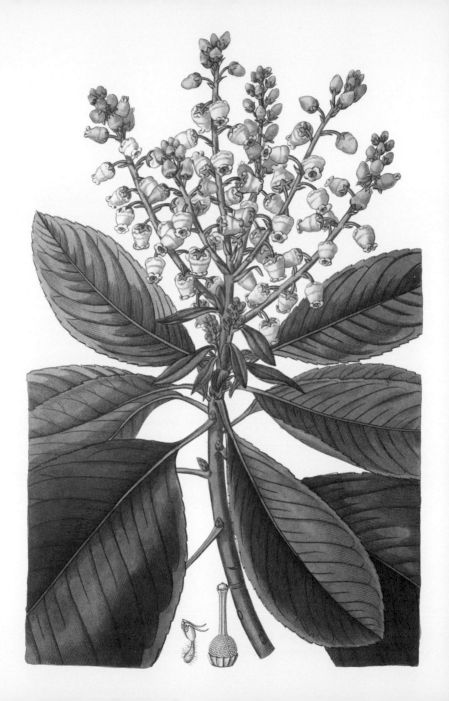

Arbutus menziesii

madrona, arbutus
by Sarah Anne Drake from John Lindley
Edwards's Botanical Register, 1835

This wonderful small tree has bright red bark
with great visual impact, which peels with age
to reveal its bright green fresh growth, making
a striking feature in any landscape, along with
copious scented white flowers in spring, and
trusses of pea-sized orange or red fruits in
autumn. This tree is well adapted to a mild
oceanic climate and enjoys life on free draining
rocky sites with low precipitation, making it an
ideal urban tree of the future.

Cercis siliquastrum

Judas tree
by Sydenham Teast Edwards
from *Curtis's Botanical Magazine*, 1808

Native to the East Mediterranean region, this tree has been in cultivation for over 300 years in the UK. With the profusion of pink blossom giving the effect of a rosy-purple mist from a distance, this tree is a lover of sun, making it ideal for gardens in the southeast of England. Legend has it that Judas hanged himself from a *Cercis siliquastrum* after the great betrayal, which inspired its common name.

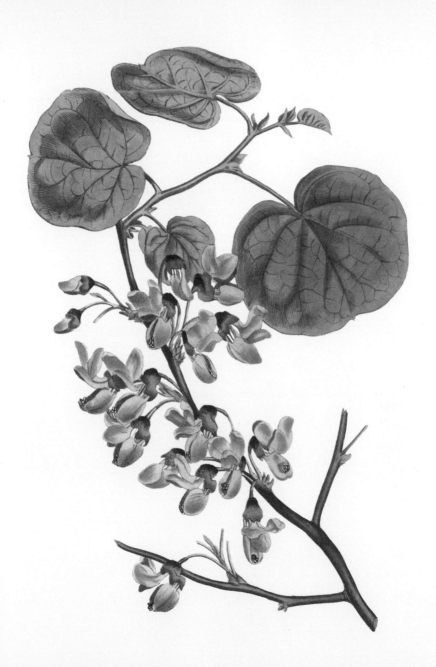

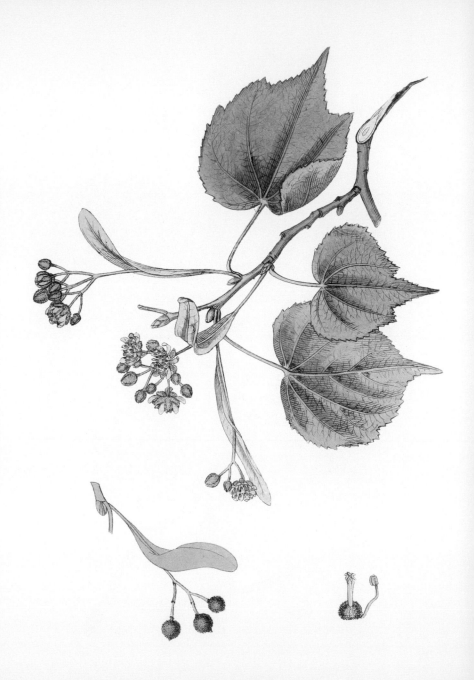

Tilia cordata

small leafed lime
from James Edward Smith
English Botany, 1846

One of Europe and western Asia's most widespread lowland temperate trees, analysis from pollen samples suggests that this species was one of the most abundant trees in the woodlands of much of lowland Britain and western Europe some 6,000 years ago. A significant decline in pollen deposits can be observed between 5,000 and 2,000 years ago. The cause of the decline has not been identified, but it's believed that human activity was the primary cause.

Parrotia persica

Persian ironwood, iron tree
by Walter Hood Fitch from
Curtis's Botanical Magazine, 1868

This small to medium tree comes into its
own in autumn, with the most breathtaking
colours of deep purple, reds and yellows. In the
wild forests of Azerbaijan, it forms the most
wonderful, picturesque landscape. It is closely
related to the witch-hazel genus, *Hamamelis*. In
early spring it produces flowers on bare twigs,
creating a hazy effect of red which is delightful
in the early spring sun.

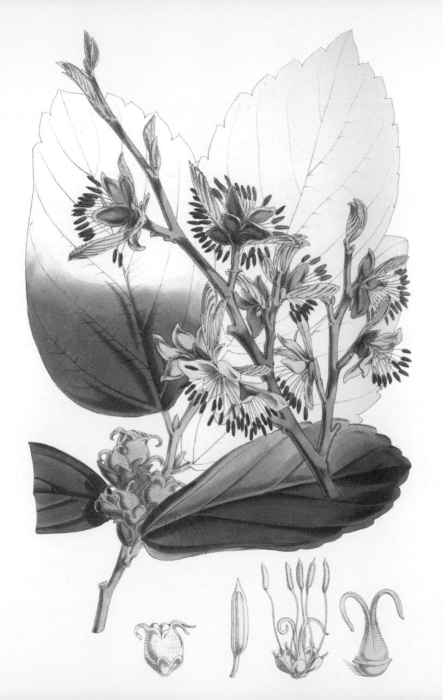

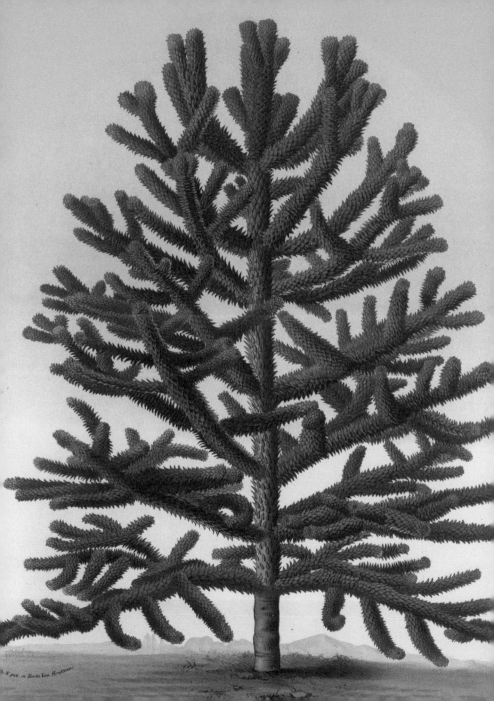

Araucaria araucana

monkey puzzle tree, Chile pine
from L. Van Houtte *Flore des Serres
et des Jardins de l'Europe*, 1845

———————————

The common name for this tree was derived in
an untraditional way. Its origin is believed to
be from the early cultivation of the species in
Britain in the 1850s. Sir William Molesworth,
a proud owner of a young specimen in his
Pencarrow garden in Cornwall, was showing his
friends this botanic wonder. One of the friends,
Charles Austin, replied with "it would puzzle a
monkey to climb that". With no common name
for the species, the name stuck.

Castanea sativa

sweet chestnut
by Otto Wilhelm Thomé
from *Flora von Deutschland, Osterreich und der Schweiz*, 1886-9

Native to southern Europe and Asia Minor, it's believed this tree was introduced to the British Isles by the Romans. It was certainly present in the British landscape before the Norman conquest. The timber from sweet chestnut can be utilised for many products like fencing and charcoal, and the fruits of this tree are consumed around the festive period as roasted chestnuts.

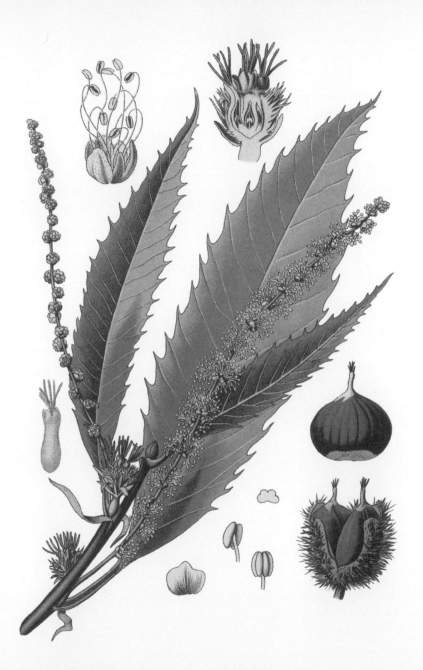

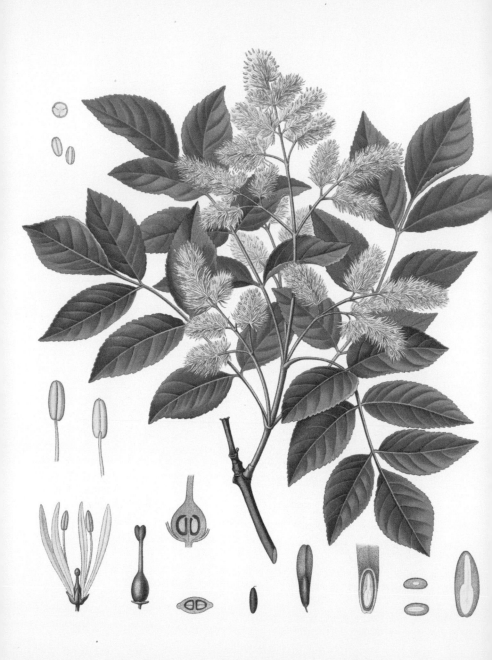

Fraxinus ornus

manna ash
from F. E. Köhler *Köhler's
Medizinal-Pflanzen*, 1887

———————

This deciduous tree is native to Southern
Europe and Asia Minor, and is a show-stopper
with breathtaking white ornamental flowers.
A sugary extract from the sap has been
harvested from the species since ancient
times, and this sweet liquid was called 'manna'
meaning 'the food of the Gods'. This yielded
its common name, manna ash.

Pinus coulteri

big-cone pine
from Franz Antoine *Die Coniferen: nach
Lambert, Loudon und Anderen*, 1840-1

The pine cones of this tree are of a gigantic
size, heavily armed with considerable weight.
First introduced to Europe for its ornamental
curiosity by the celebrated botanist and
explorer David Douglas in 1832, the tree is well
adapted for life in dry conditions and is a good
pine species for dry landscapes.

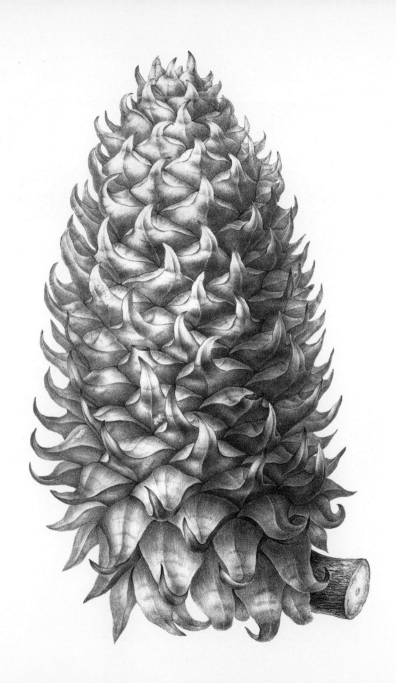

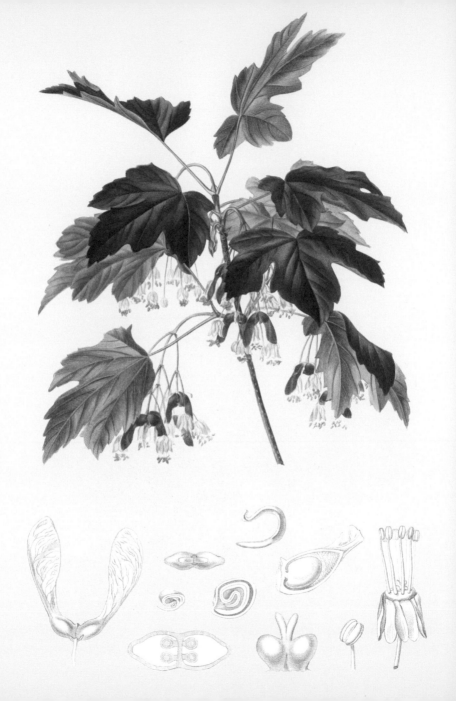

Acer opalus

Italian maple
from C. V. D. d'Orbigny *Dictionnaire
Universel d'Histoire Naturelle*, 1839-49

This is one of the most ornamental of early-flowering trees, producing its blossoms regularly and in great abundance in March and April. In this regard it is comparable to forms of *Acer hyrcanum*, though it offers more later in the year, with good shows of yellow and orange autumn colour if afforded optimal conditions.

Nyssa ogeche

white tupelo, river lime, ogeche lime
by Pancrace Bessa
from Francois Andre Michaux
The North American Sylva, 1819

This lovely tree can grow to 15 m (50 ft) and
is deciduous, from the United States. An early
spring flowering tree, the seeds ripen from late
summer to early autumn. Believed to have been
first introduced to Europe as early as 1806, but
with the cooler winters it never truly flourished.
However, with the climate warming, the
southeast of England could become its home.

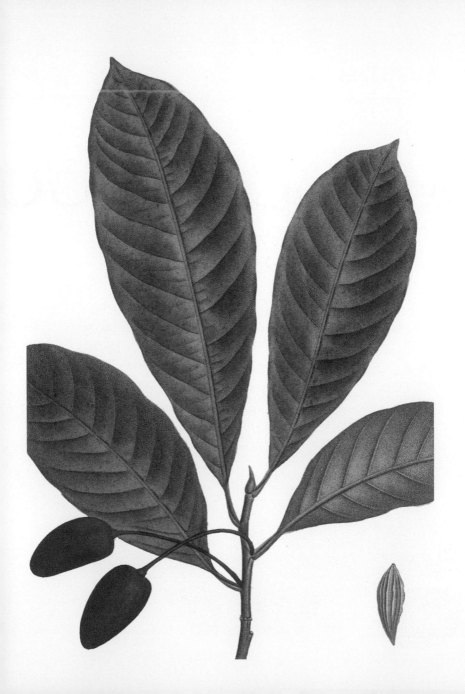

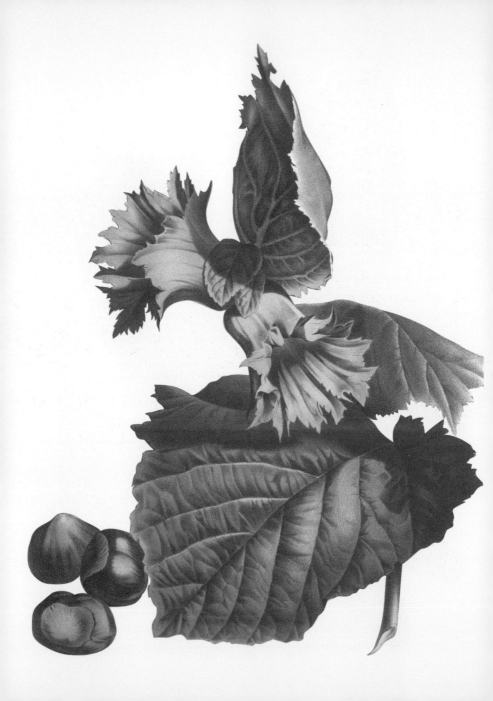

Corylus colurna

Turkish hazel
from L. Van Houtte *Flore des Serres
et des Jardins de l'Europe*, 1875

The Turkish hazel was first introduced into
English gardens in the middle of the 16th
century as an ornamental tree. It is very well
adapted to grow in difficult conditions making
it an ideal urban tree. This suitability for urban
plantings comes from its native environment
of South East Europe and Asia Minor, with
warmer drier climates.

Aesculus californica

Californian chestnut, common buckeye
by Walter Hood Fitch
from *Curtis's Botanical Magazine,* 1858

This tree is at its best in June to August
when the sweet-scented, white to pale pink
upright flowers are shown off. Commonly
called the Californian chestnut, it is indeed
native to California but is very adapted to the
Mediterranean climate by cleverly growing
during the warmer, wetter autumn months and
again in spring. It has the ability to deal with
extreme summer heat and drought by going into
dormancy which prevents vascular stress.

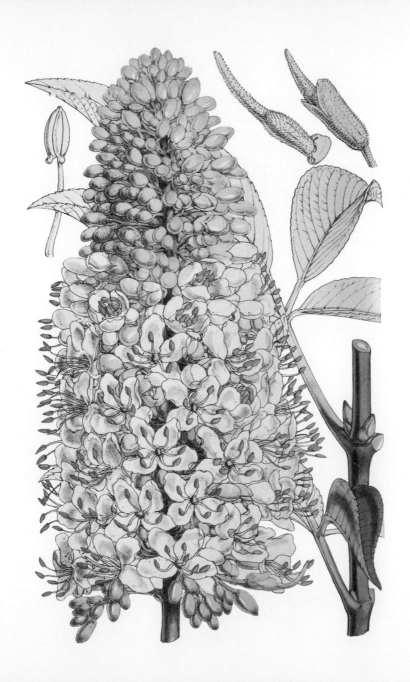

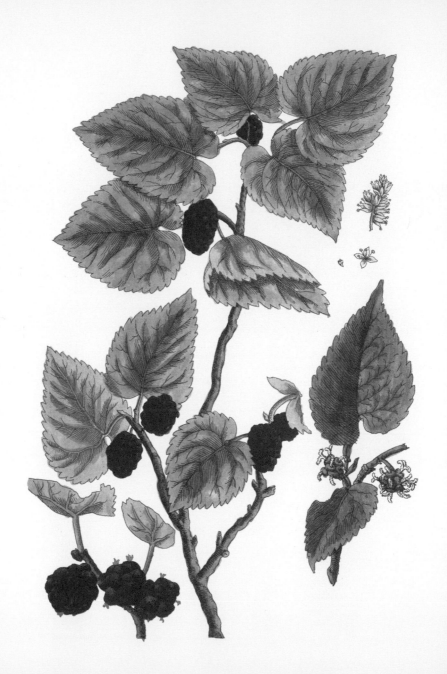

Morus nigra

black mulberry
by Elizabeth Blackwell
from Elizabeth Blackwell
Herbarium Blackwellianum, 1750-73

The black mulberry has been in cultivation for
so long, people have forgotten its origin. The
consensus is that it was native to the region
bordering the southern Caspian Sea; today's
Iran, Azerbaijan and Turkmenistan. This tree
has long been valued for its fruit in the region,
and for this reason it has been in cultivation
since the 8th century BCE.

Acer campestre

field maple, hedge maple
from James Edward Smith
English Botany, 1846

One of Europe's most widespread maple
species, reaching to the far west of Britain
and Ireland, through mainland Europe, and
south to western Asia. This species is one of
the most adaptable and least demanding of all
maple species in cultivation, with its ability
to tolerate pollution making it ideally suited
for urban tree planting.

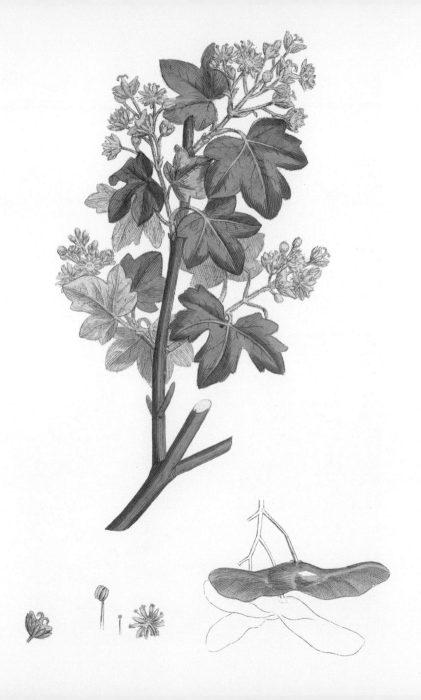

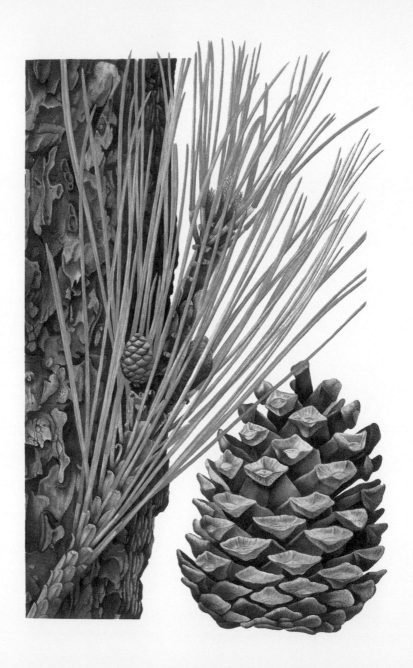

Pinus brutia

Turkish pine, Calabrian pine
by Ann Farrer from
Curtis's Botanical Magazine, 1999

As with many pine species, this is widely
planted for economic use in forestry within
its native range of Turkey and Cyprus through
the Mediterranean region east to Pakistan. It
is believed that the pest Israeli pine bast scale
(*Matsucoccus josephi*) was introduced on fresh
timber of *Pinus brutia* from Cyprus by the
British forces during the First World War.

Viburnum tinus

laurustinus
by Mary Anne Stebbing,
Kew Collection, 1946

This is a small tree/large shrub from the
Mediterranean and North Africa. This species
has been in cultivation since the 16th century,
and the tree comes into its own in gardens,
forming flowers from November to April.
It definitely performs best when in full sun. The
fruits of this tree are an attractive indigo-blue,
ultimately black in colour.

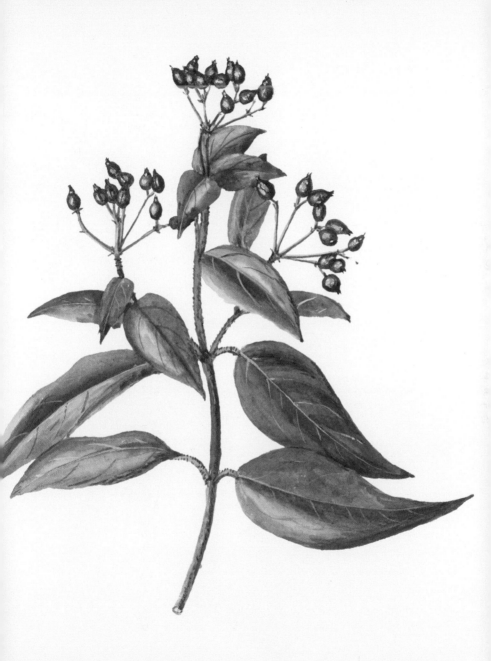

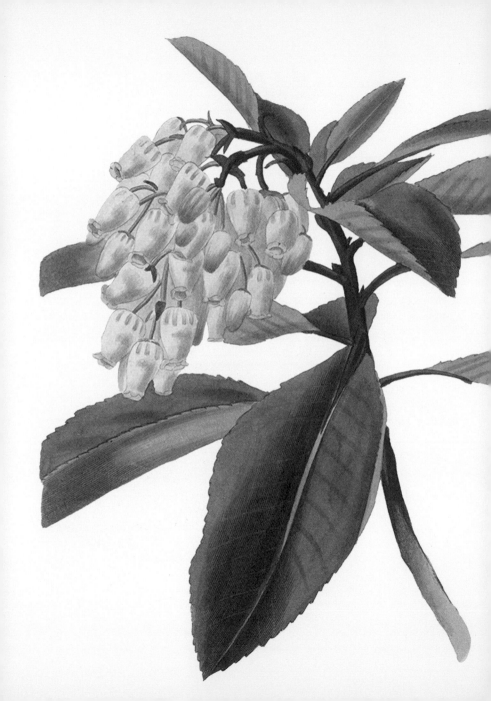

Arbutus andrachne

Greek strawberry tree,
Cyprus strawberry tree
by George Cooke from Conrad Loddiges
The Botanical Cabinet, 1817-33

Like its American cousin, this species has
great flowers in spring with the trademark
orange-red bark peeling to reveal fresh
new green growth as the growing season
continues. This tree may not withstand the
cold away from its Mediterranean home, but
with the climate changing to warmer and
wetter, this visually impactful tree could start
to become a feature of the urban landscape.

Ostrya carpinifolia

European hop-hornbeam
from Pierre Mouillefert
Traité des Arbres et Arbrissaux, 1892-8

The European hop-hornbeam is named after
its seeds which resemble those of hops, and is
widespread throughout the south and east of
Europe. Although abundant through Europe, it
seems it didn't make an appearance in English
gardens until 1724, first listed in the Kensington
nurseryman Robert Furber's catalogue.

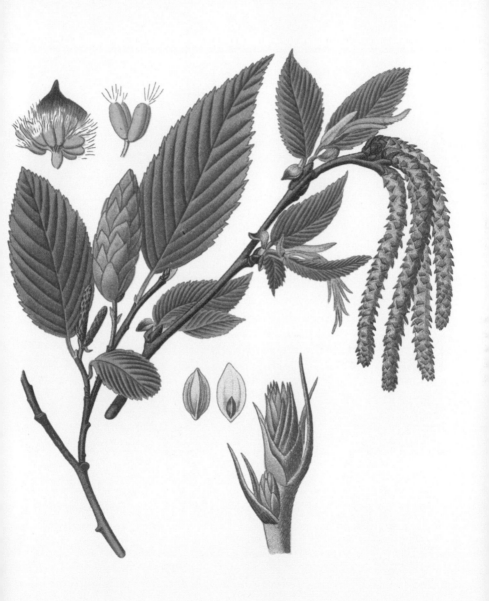

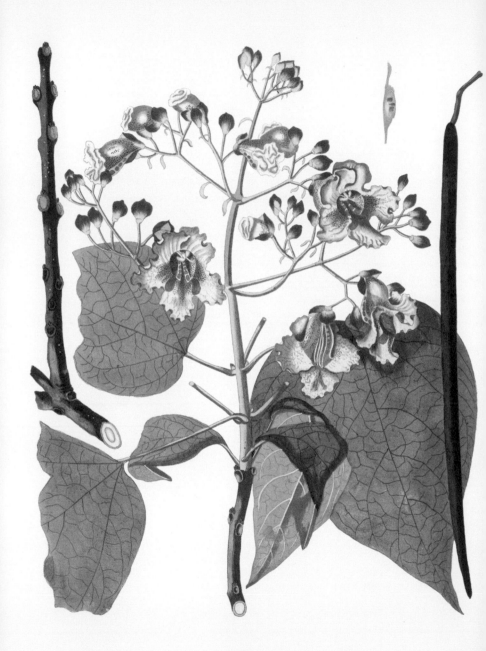

Catalpa bignonioides

Indian bean tree, common catalpa
from Johan Carl Krauss *Afbeeldingen der Fraaiste, Meest Uitheemsche Boomen en Heesters*, 1802

This tree is one of the real show-offs when it comes to flowering trees, blooming in late summer. Native to the eastern United States, it was first introduced into cultivation in the UK in 1726 and is commonly planted in parks and large gardens. The 'Indian' part of the common name derives from the genus name *Catalpa*, which was named after the native American tribe Catawba.

Crataegus tanacetifolia

tansy-leaved thorn, Syrian haw
from Pierre Mouillefert
Traité des Arbres et Arbrissaux, 1892-8

This rare and fragrant flowering tree is native to Asia Minor and was first introduced to the UK in 1789. The flowers make a show in June and the red fruits ripen in September. This tree is a hermaphrodite, with both male and female organs, and pollination is carried out by midges. It is well adapted to deal with dry and drought conditions, making it a perfect small garden tree.

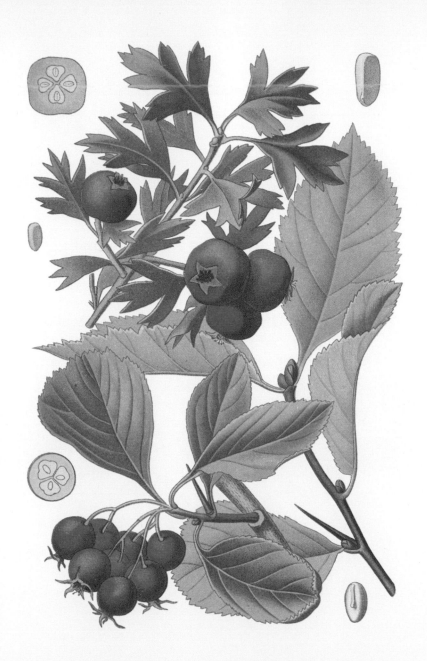

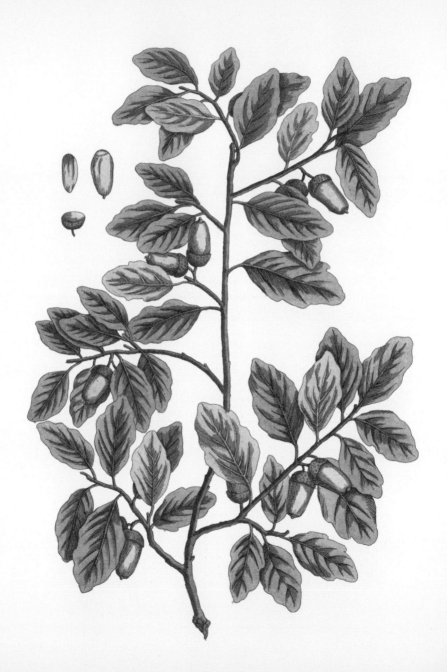

Quercus suber

cork oak
by Elizabeth Blackwell from
Elizabeth Blackwell *A Curious Herbal*, 1737

The bark of this species has been utilised for
cork since Roman times. Famously used in glass
wine bottles, cork is now being utilised as a
vegan alternative to leather.

ILLUSTRATION SOURCES

Books and Journals

Alpini, P. (1627). *De Plantis Exoticis Libri Duo.* Jo. Guerilium, Venice.

Antoine, F. (1840-1). *Die Coniferen: nach Lambert, Loudon und Anderen.* Commission der F. Beck'schen Universitäts-Buchhandlung, Vienna.

Blackwell, E. (1737). *A Curious Herbal.* Volume 1. J. Nourse, London.

Blackwell, E. (1750-73). *Herbarium Blackwellianum.* Volume 2. Typis Io. Iosephi Freischmanni, Nuremberg.

Descourtilz, M. É. (1821-9). *Flore Pittoresque et Médicale des Antilles.* Volume 7. Chez Corsnier, Paris.

Duhamel du Monceau, H. L. (1800-19). *Traité des Arbres et Arbustes.* Volume 2. Didot *et al.*, Paris.

Edwards, S. T. (1822). *Edwards' Botanical Register.* Volume 8. James Ridgway and Sons, London.

Hooker, J. D. (1868). *Parrotia persica. Curtis's Botanical Magazine.* Volume 94, t. 5744.

Hooker, W. J. (1858). *Aesculus californica. Curtis's Botanical Magazine.* Volume 84, t. 5077.

Köhler, F. E. (1887). *Köhler's Medizinal-Pflanzen.* Volume 1. F. E. Köhler, Gera-Untermhaus.

Krauss, J. C. (1802). *Afbeeldingen der Fraaiste, Meest Uitheemsche Boomen en Heesters.* Johannes Allart, Amsterdam.

Lindley, J. (1835). *Arbutus menziesii. Edwards's Botanical Register.* Volume 21, t. 1753.

Lindman, C. A. M. (1922-6). *Bilder ur Nordens Flora.* Volume 2. Wahlström & Widstrand, Stockholm.

Loddiges, C. (1817-33). *The Botanical Cabinet.* Volume 6. John and Arthur Arch, London.

Mathew, B. (1999). *Pinus brutia. Curtis's Botanical Magazine.* Volume 16, t. 367.

Mattioli, P. A. (1563). *New Kreüterbuch*. Georgen Melantrich von Auentin, Prague.

Michaux, F. A. (1819). *The North American Sylva*. Volume 1 & 2. C. D'Hautel, Paris.

Mouillefert, P. (1892-8). *Traité des Arbres et Arbrissaux*. Atlas. P. Klincksieck, Paris.

d'Orbigny, C. V. D. (1839-49). *Dictionnaire Universel d'Histoire Naturelle*. Volume 3. A. Pilon, Paris.

von Pallas P. S. (1784-8). *Flora Rossica*. Volume 1. E Typographia Imperiali J. J. Weitbrecht, Petropoli.

Ravenscroft, J. E. (1863-84). *The Pinetum Britannicum*. W. Blackwood & Sons, Edinburgh, London.

Rix, M. (2012). *Quercus crassifolia. Curtis's Botanical Magazine*. Volume 29, t. 735.

Sims, J. (1808). *Cercis siliquastrum. Curtis's Botanical Magazine*. Volume 28, t. 1138.

Smith, J. E. (1846). *English Botany*. Volume 2. Richard Taylor, London.

Stephenson, J. (1835). *Medical Botany*. Volume 2. J. Churchill, London.

Thomé, O. W. (1886-9). *Flora von Deutschland Österreich und der Schweiz*. Volume 2. F. E. Köhler, Gera-Untermhaus.

Trew, C. J. (1750-73). *Plantae Selectae*. Volume 4. Nuremberg.

Van Houtte, L. (1875). *Aesculus rubicunda. Flore des Serres et des Jardins de l'Europe*. Volume 21.

Van Houtte, L. (1845). *Araucaria imbricata. Flore des Serres et des Jardins de l'Europe*. Volume 15.

Van Houtte, L. (1875). *Corylus colurna. Flore des Serres et des Jardins de l'Europe*. Volume 21.

Art Collections

Marianne North (1830-90). Comprising over 800 oils on paper, showing plants in their natural settings, painted by North, who recorded the world's flora during travels from 1871 to 1885, with visits to 16 countries

in 5 continents. The main collection is on display in the Marianne North Gallery at Kew Gardens, bequeathed by North and built according to her instructions, first opened in 1882.

FURTHER READING

Harrison, C. and Kirkham, T. (2019). *Remarkable Trees*. Thames & Hudson, London in association with the Royal Botanic Gardens, Kew.

Mills, C. (2016). *The Botanical Treasury*. Welbeck Publishing, London in association with the Royal Botanic Gardens, Kew.

North, M. and Mills, C. (2018). *Marianne North: The Kew Collection*. Royal Botanic Gardens, Kew.

Payne, M. (2016). *Marianne North: A Very Intrepid Painter*, revised edition. Royal Botanic Gardens, Kew.

Scott, K. and Kirkham, T. (2022). *Arboretum*. Big Picture Press, London in association with the Royal Botanic Gardens, Kew.

ACKNOWLEDGEMENTS

Kew Publishing would like to thank the following for their help with this publication: Kew's Library and Archives team; Paul Little for digitisation work; Christabel King for permission to use her illustration on page 35; Ann Farrer for permission to use her illustration on page 78; Peter H. Raven Library/Missouri Botanical Garden for supplying images on pages 33 and 54.

INDEX

© The Board of Trustees of the Royal Botanic Gardens, Kew 2023

Illustrations © the Board of Trustees of the Royal Botanic Gardens, Kew, unless otherwise stated (see acknowledgements p. 94)

The authors have asserted their rights as authors of this work in accordance with the Copyright, Designs and Patents Act 1988

First published in 2023
Royal Botanic Gardens, Kew,
Richmond, Surrey, TW9 3AB, UK
www.kew.org

ISBN 978 1 84246 782 4

Distributed on behalf of the Royal Botanic Gardens, Kew in North America by the University of Chicago Press, 1427 East 60th St, Chicago, IL 60637, USA.

British Library Cataloguing in Publication Data
A catalogue record for this book is available from the British Library

Design: Ocky Murray
Page layout: Kevin Knight
Production Manager: Georgie Hills
Copy-editing: Ruth Linklater

Printed and bound in Italy by Printer Trento srl.

Endpapers: Oaks from Francois Andre Michaux *The North American Sylva*, 1819

p2: *Acer*, maple, from Henri Louis Duhamel du Monceau *Traité des Arbres et Arbustes*, 1800-19

p4: *Cedrus deodara*, Himalayan cedar, from Edward James Ravenscroft *The Pinetum Britannicum*, 1863-84

p10-11: *The Mariposa Grove of Big Trees, California* by Marianne North from the Marianne North Collection, Kew, 1875

For information or to purchase all Kew titles please visit shop.kew.org/kewbooksonline or email publishing@kew.org

Kew's mission is to understand and protect plants and fungi, for the wellbeing of people and the future of all life on Earth.

Kew receives approximately one third of its funding from Government through the Department for Environment, Food and Rural Affairs (Defra). All other funding needed to support Kew's vital work comes from members, foundations, donors and commercial activities, including book sales.

Publishers note about names
The scientific names of the plants featured in this book are current, Kew accepted names at the time of going to press. They may differ from those used in original-source publications. The common names given are those most often used in the English language, or sometimes vernacular names used for the plants in their native countries.

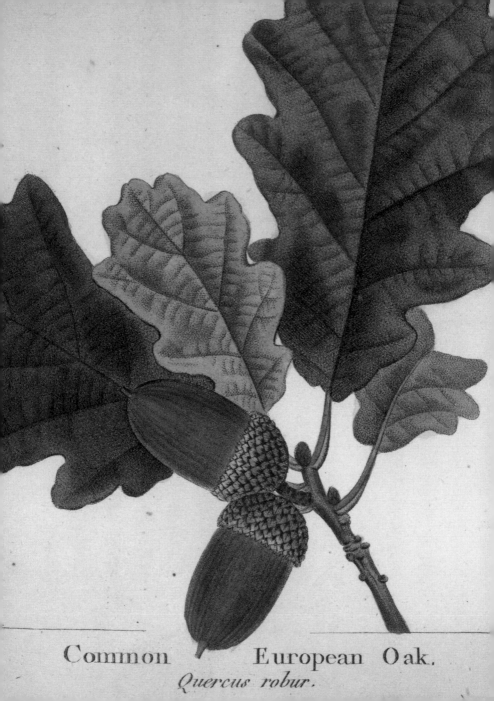

Common European Oak.
Quercus robur.